T0199016

Under The Same Sky

Artistic and Poetic Contribution to World Peace

JoAnn Sims

To order additional copies of this book, contact:
Xlibris
844-714-8691
www.Xlibris.com
Orders@Xlibris.com

Library of Congress Control Number: 2022916965
ISBN: Softcover 978-1-6641-9923-1
 Hardcover 978-1-6641-9924-8
 EBook 978-1-6641-9922-4

Print information available on the last page

Rev. date: 09/29/2022

Dedication

To the World Friendship Center in Hiroshima, Japan, for their dedication and tireless efforts to promote peace one friend at a time.

To Mike Stern for his inspirational music and dedication to peace and nonviolence.

To Thomas Locker for his book *Cloud Dance*.

To my family for their support in helping me pursue my passions for peace and painting.

Artist/Author Notes

This series of oil painting skyscapes is my personal contribution to world peace.

If we could all truly realize we share the same sky, perhaps the people of the world would embrace the love of cooperation and peace.

Without the artificial boundaries of politics, nationalities, religions, or continents, perhaps the world would turn away from competition and violence and embrace the love that surrounds us all.

I invite you to see our sky in never-ending beauty, diversity, and a true expression of the love in the universe that surrounds the earth as we all live under the same sky.

MORNING

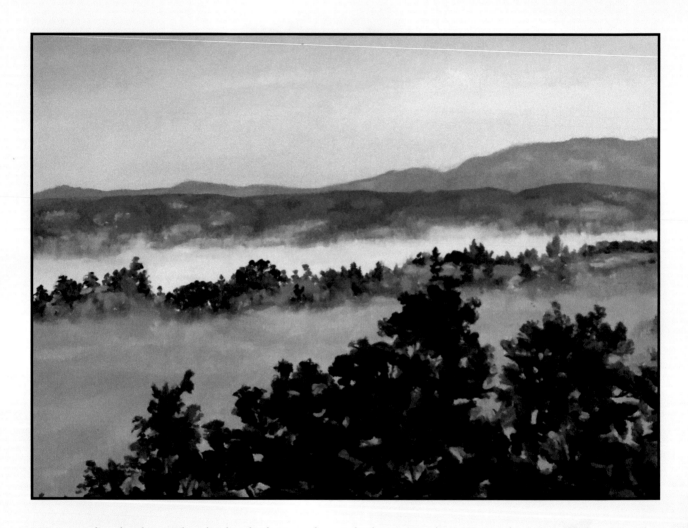

Morning has broken. The sky knelt during the night between the trees and in the valleys. The sky that has not fallen is faintly reflecting the rising sun.

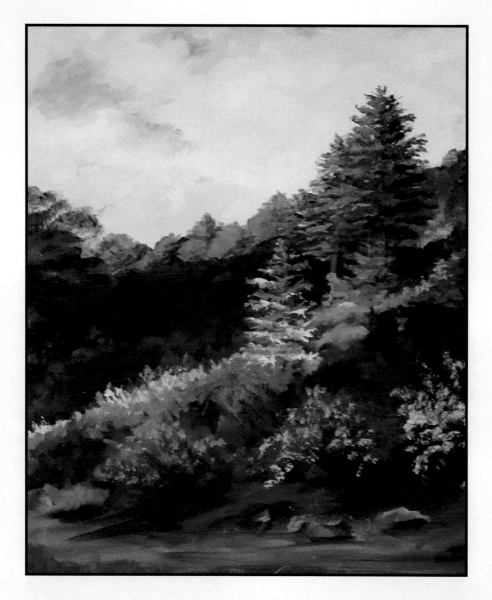

The sunlight streams through the trees. The clouds are soft, fresh, and white. The blue sky peeks from behind playful clouds.

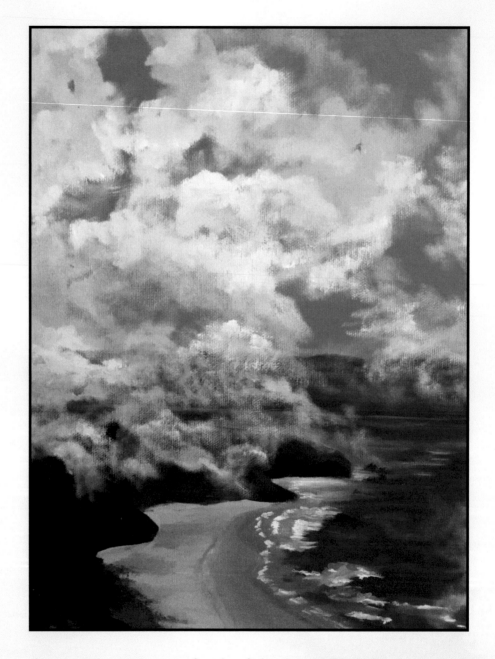

The fog kisses the sea and returns to its family of clouds, wet from the embrace of the ocean. It is a mix of sun and shadow, wispy breezes, and ever-rhythmic soft surf.

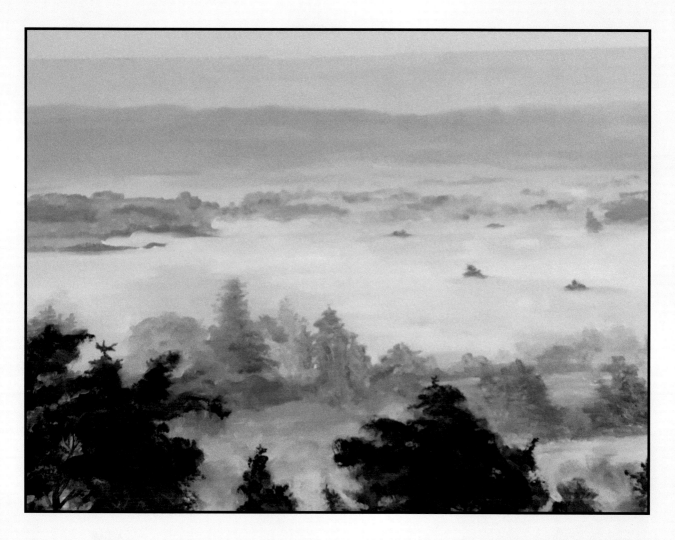

The sky touches the hills with a blanket of fog, quilting first in yellow, then orange, and then soft white, snuggling up and covering all but tall trees and giant oaks. The golden sky promises a beautiful fall day.

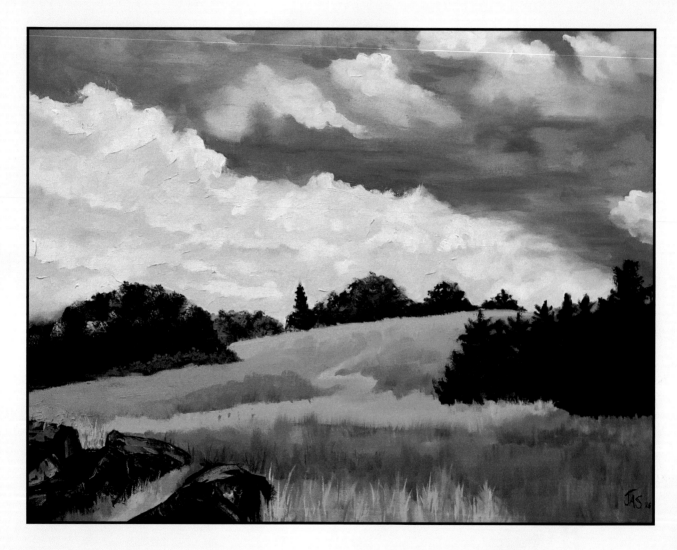

Robust clouds call to their friends of wispy nature, "Come join our family!"

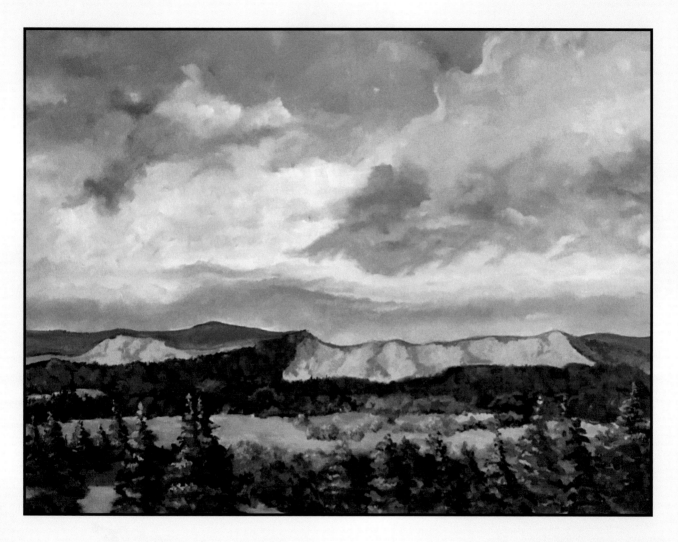

The sky reflects the diversity of the land, honoring each color and shadow. The valley becomes a mirror of the sky, or perhaps it is the sky that holds the diversity of the valley.

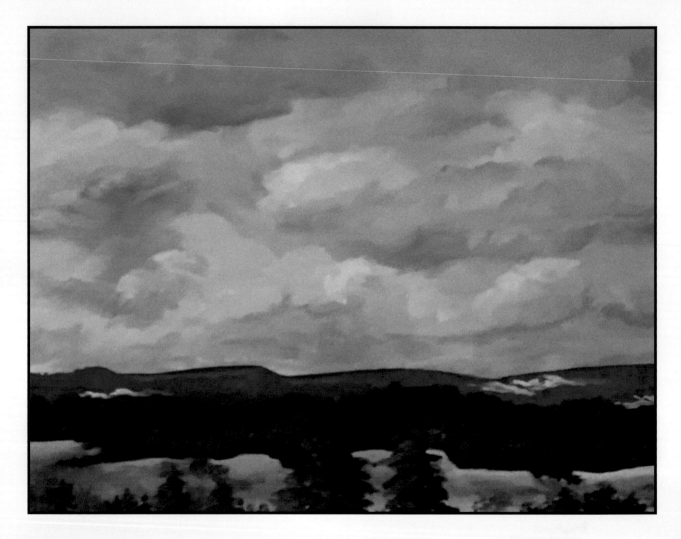

Even on quiet late winter days, the sky adds fluidity, depth, dance, and action. The clouds fill the sky with hints of highlights and maybe even snow.

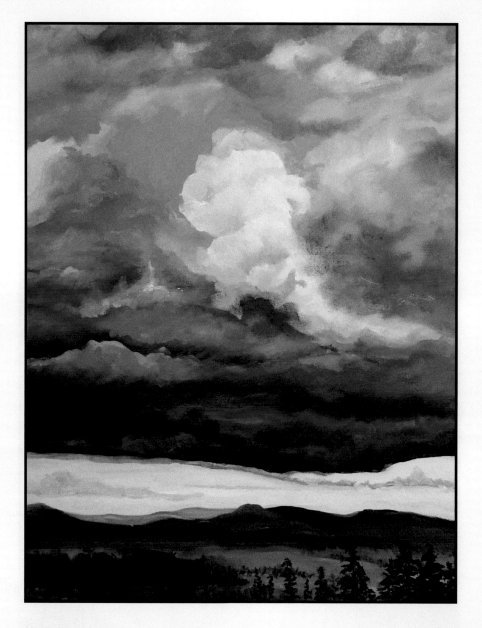

A sky of blue and faint gold caresses heavy clouds with hints of possible rain. Those dark clouds hold and even lift up the sunstruck cloud rising to the blue beyond. This is a symbol of lifting all—gray, white, brown, or black.

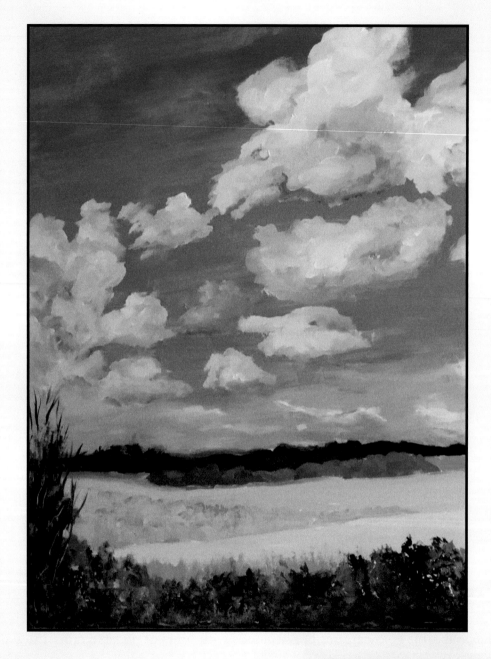

Popcorn shaped clouds dance across the slightly gray and bluish sky. They skirt over the freshly harvested field.

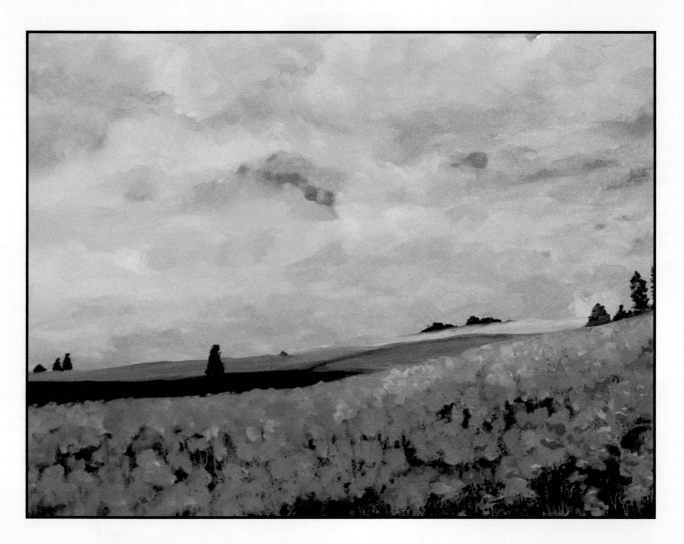

Joyous clouds reflect bursts of summer blossoms, nearly filling the sky. Fresh, happy clouds spotlight the flowers between their softness.

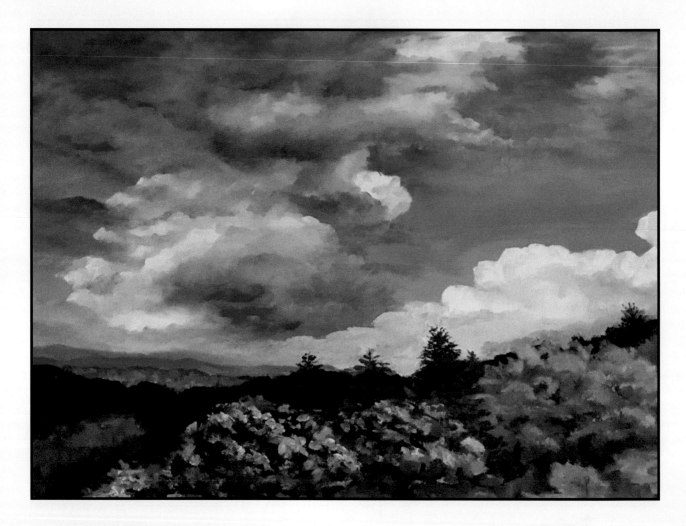

Potential rain comes from heavy sinking clouds. Mature clouds catch the sunlight in front of the shadow. This sky also holds developing clouds, wondering which family to join.

MOUNTAINS

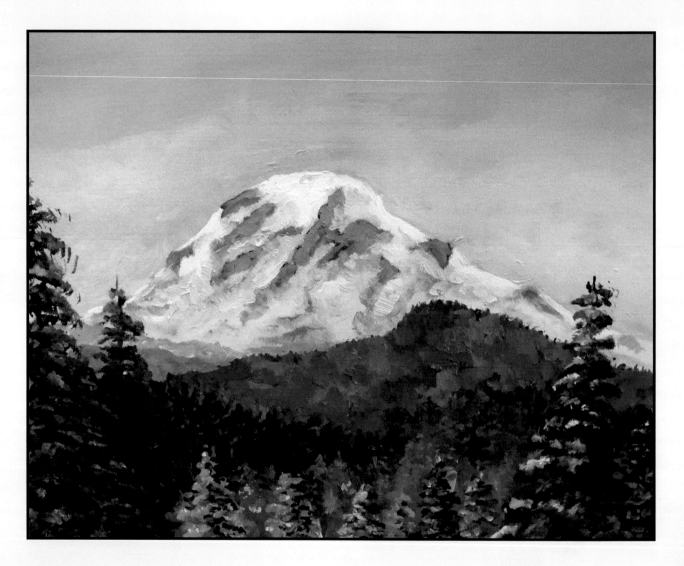

The high mountain seems to caress the sky, touching the blue beyond even its heights. The sky is so high that clouds barely show themselves against the soft, infinite blue.

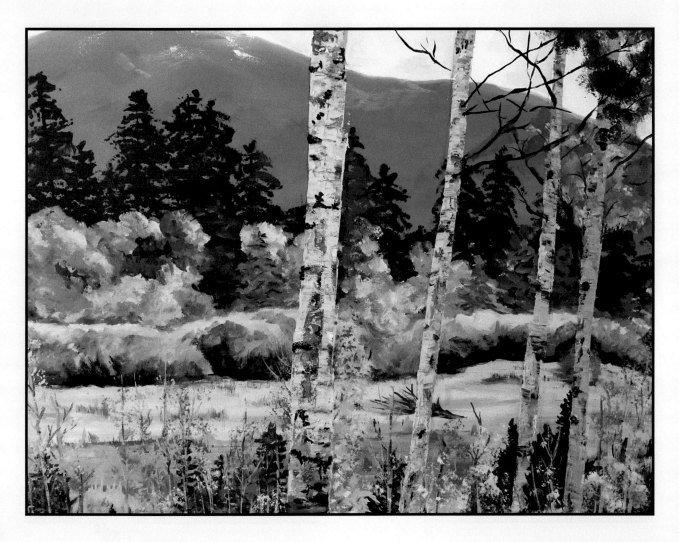

Sometimes the sky becomes a fresh palate for the glowing colors of autumn. There is a hint of snow, an early forecast of winter to come.

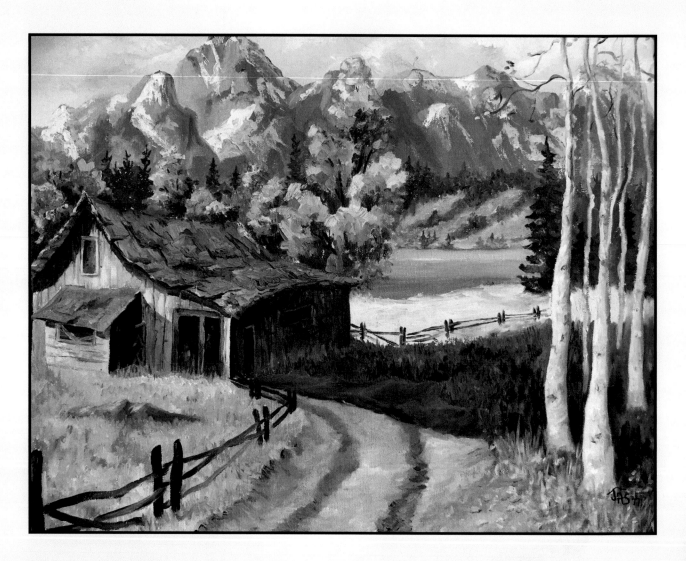

Dancing clouds reflect the peaks of high mountain country. The sky is even more ancient than the snow-clad peaks. The sky, never exhausted, leans against the autumn aspens and a tired shack.

VALLEY/PLAINS

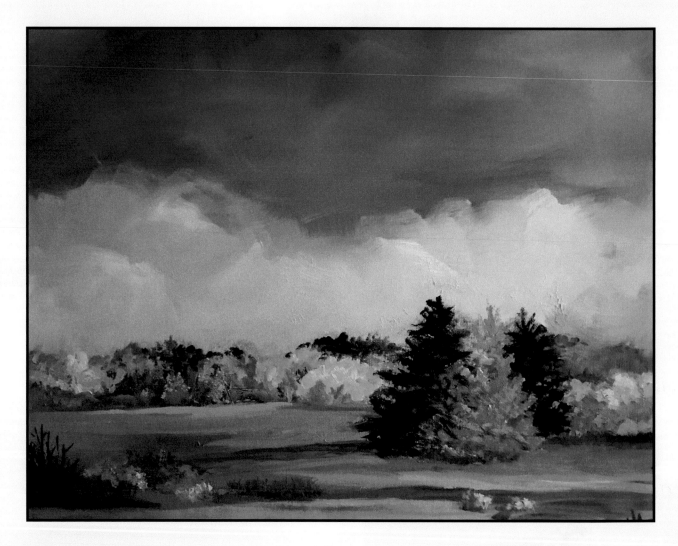

Expansive and ever changing, the horizon births dense clouds that rise and develop into many shapes and sizes.

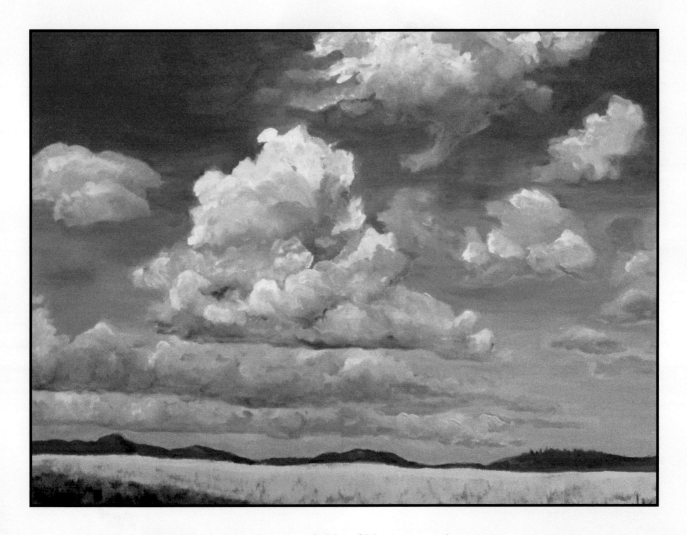

On a spring day, cumulus clouds play over fields of blooming tulips.

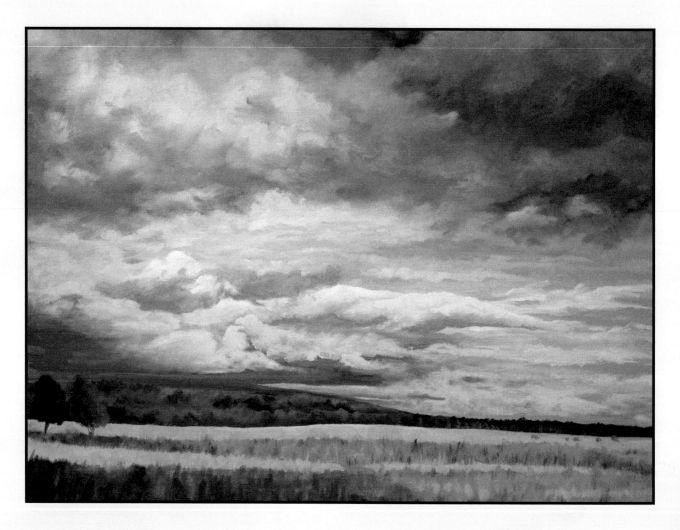

In a celestial symphony, an orchestra of clouds play, each bringing its own beauty to the sky.

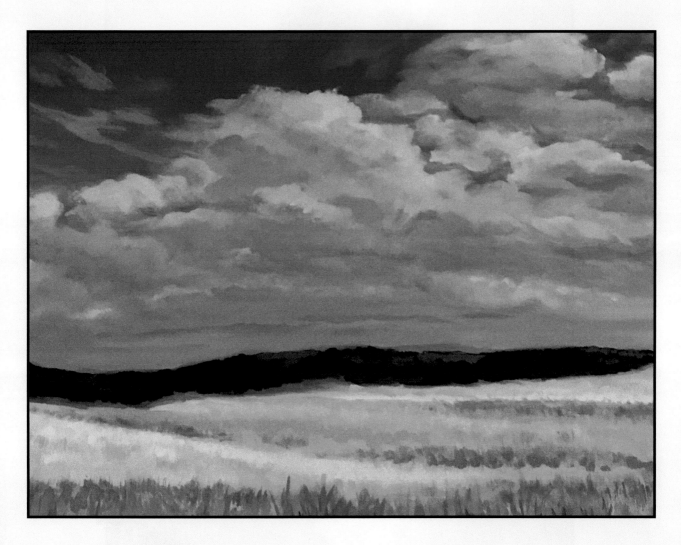

A burst of happy clouds radiates across the sky.

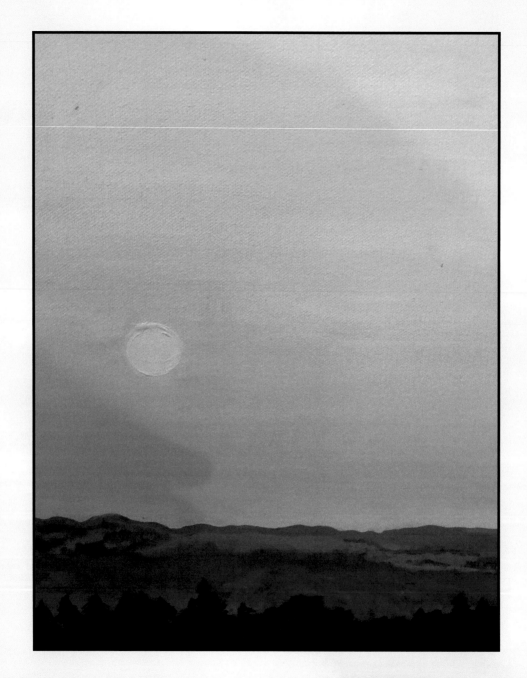

The sun hides behind a sky of forest fire smoke in gradient shades of pink and red.

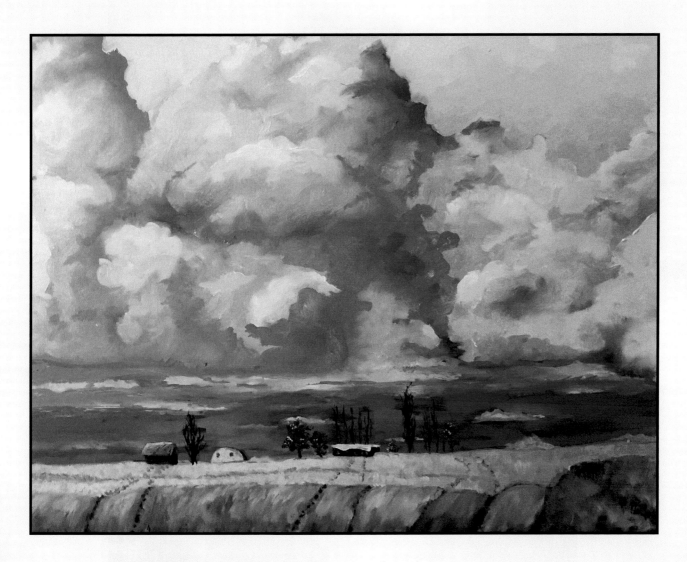

Enormous clouds build and dwarf the farm homestead.

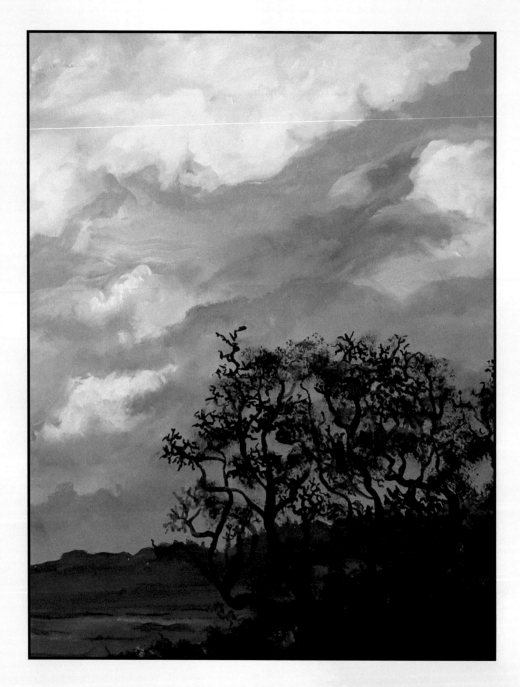

The promise of summer appears in the clouds of blue and gold.

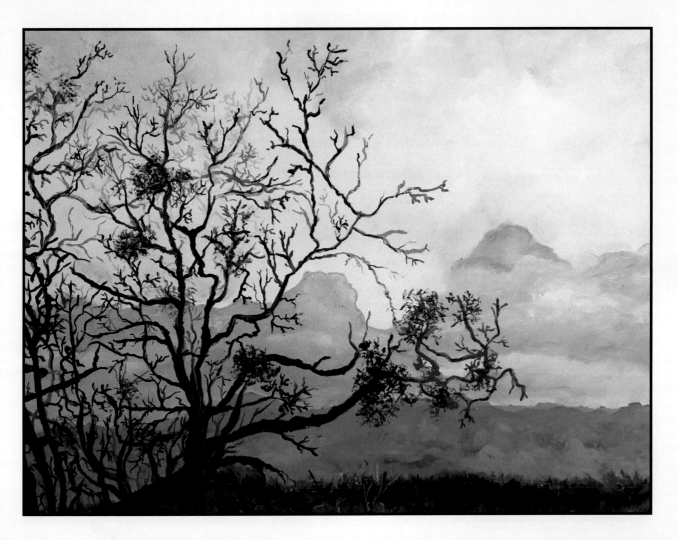

Winter, too, has its beauty. There are no leaves, only clouds that hide the sun and bring a sky of gold dust to the eye.

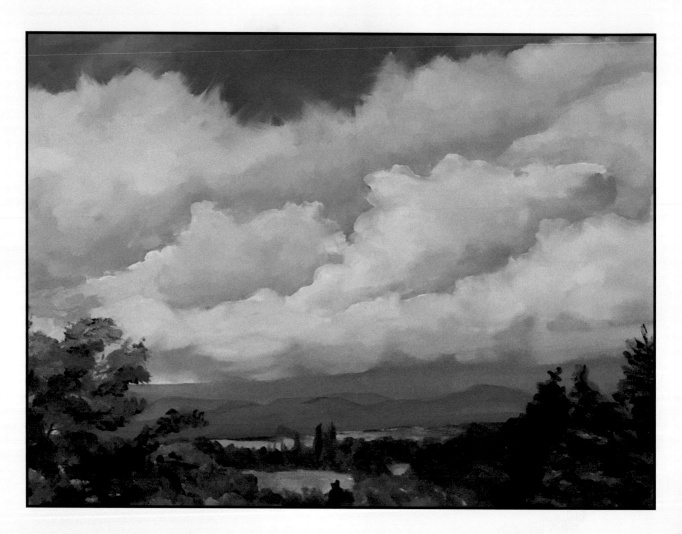

Clouds travel in a sapphire sky.

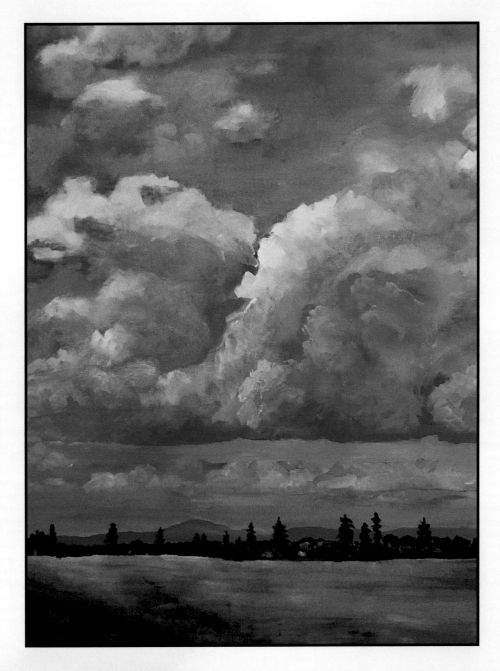

In a summer drama, cumulus clouds build, the sun highlighting the magnificence of the day.

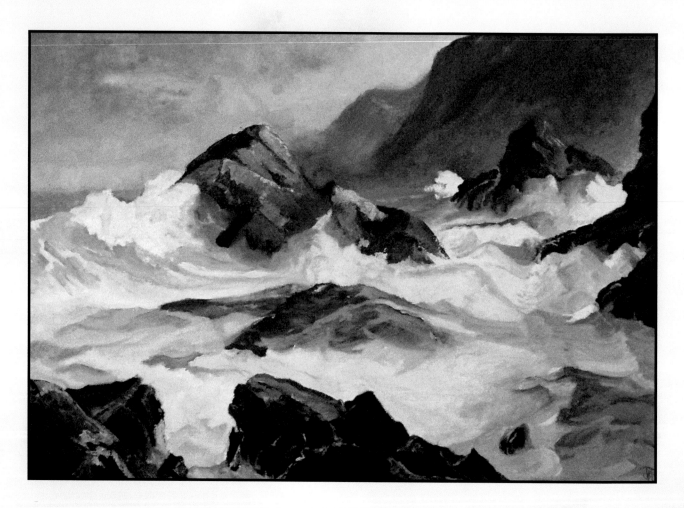

A quiet sky showcases the turbulent sea near the rocky shore.

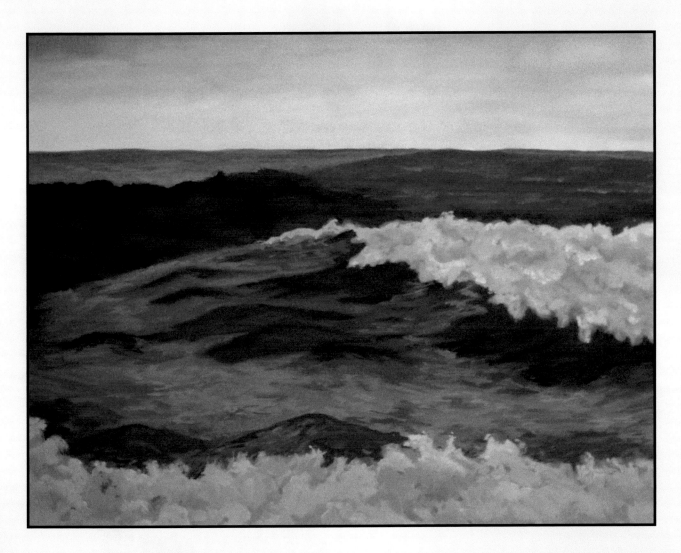

A purple sea reflects the golden sky.

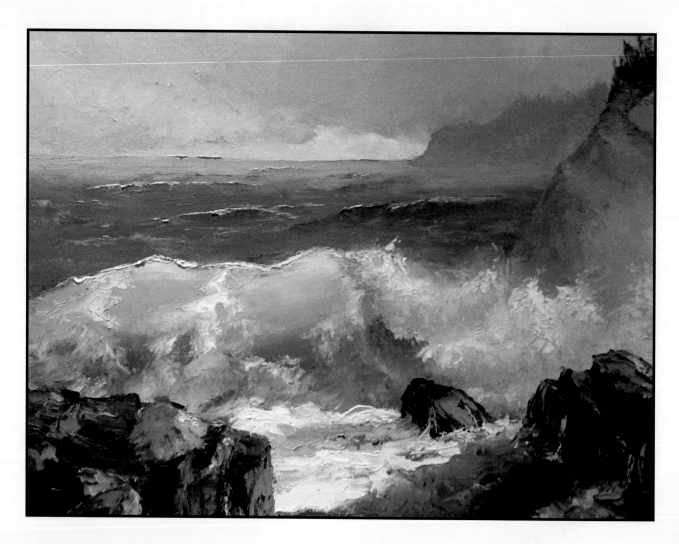

Pink, purple, and golden skies highlight a wave about to break.

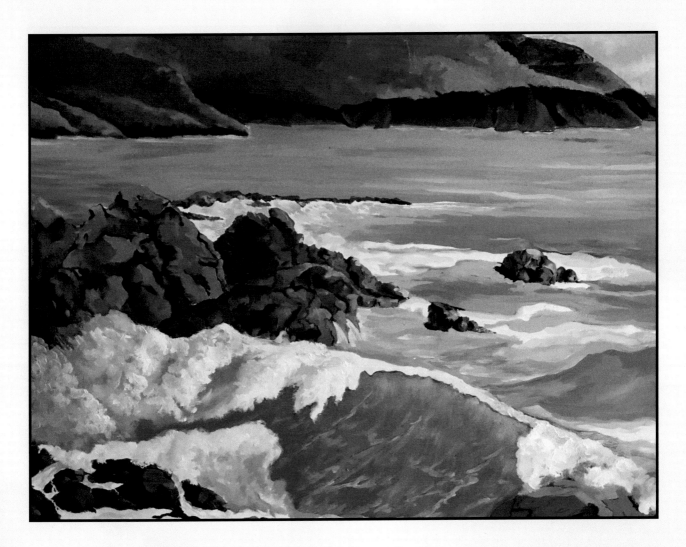

A distant sky provides a mirror for breaking waves.

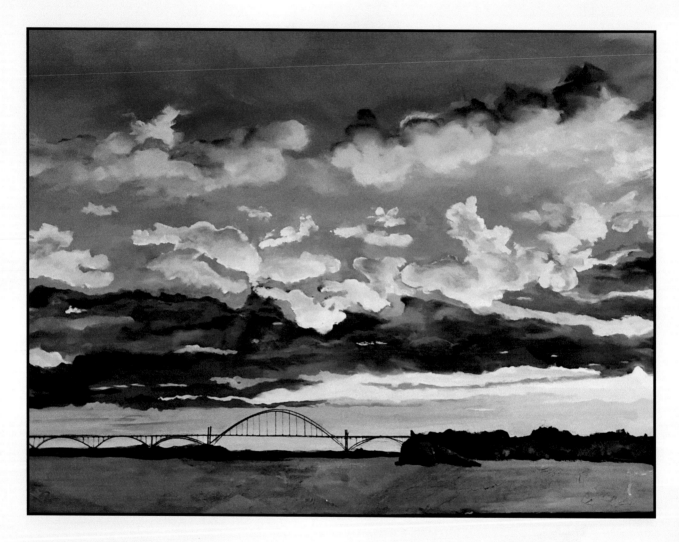

A sky with clouds of all shapes and colors serves as a bridge that connects us all with peace and justice.

SUNSET

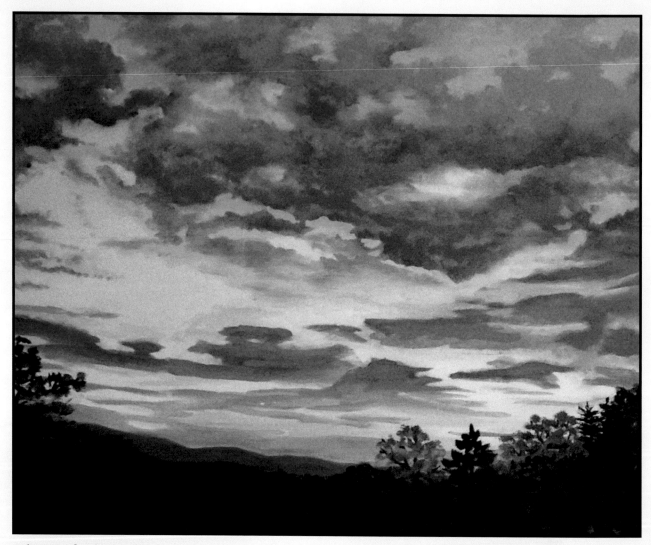

A burst of color and drama appears as the sky's hues promise a beautiful kiss good night to the day.

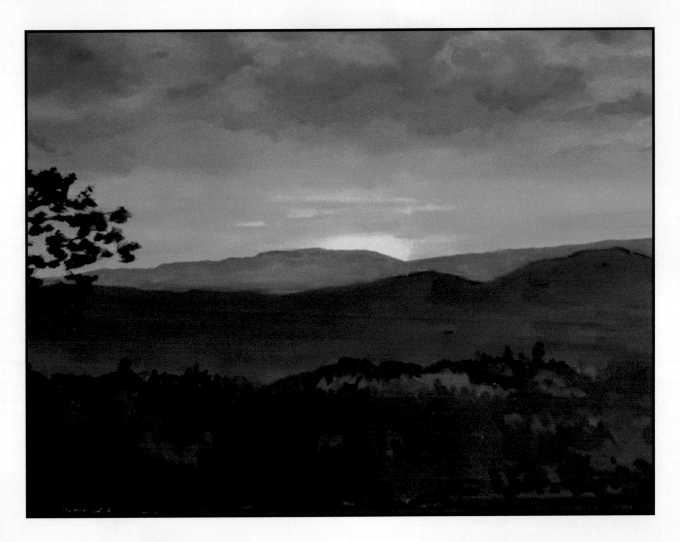

Shadows deepen. The clouds begin to glow as the sun slips behind the hill.

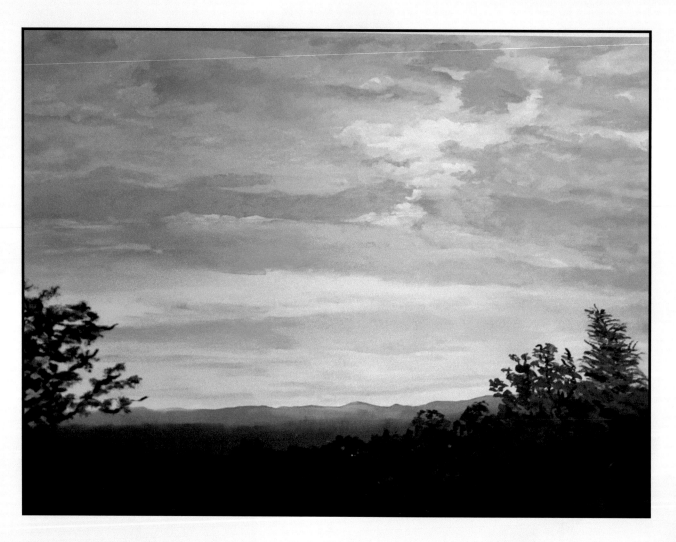

A golden light fills the sky and ignites the hills with a glowing beauty.

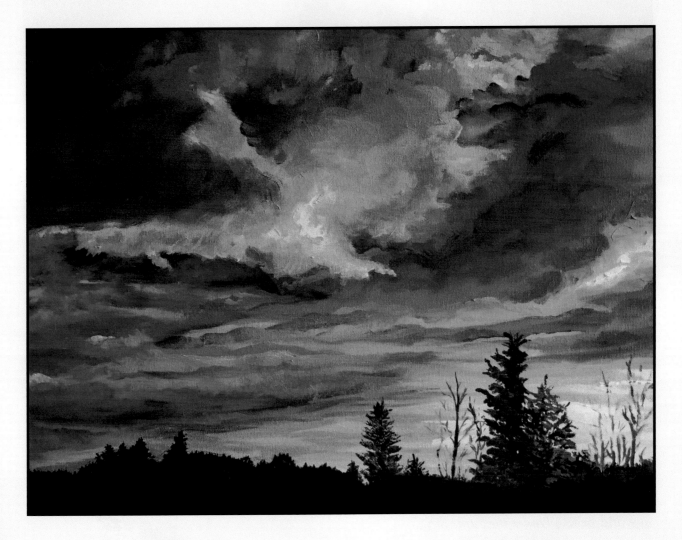

This is drama at its best—a sky that reflects a rainbow of clouds, colors, and shapes.

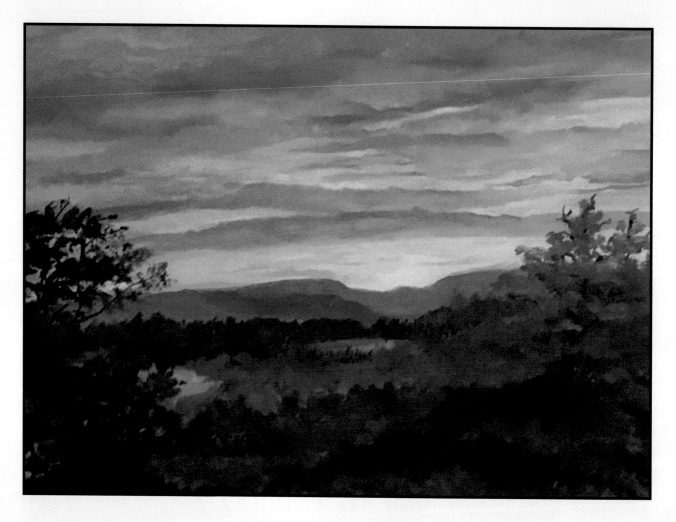

This is a warm and dusty view of clouds, valley, hills, and sky—a sweet farewell to my contribution to world peace, *Under the Same Sky*.

I invite you to see our sky in never-ending diversity and a true expression of the love in the universe that surrounds the entire earth as we all live under the same sky.

Artist / Author

JoAnn Sims is an artist, author, educator, and peace activist. Discouraged by the conflicts around the world, within countries, and between nations, she was perplexed about what one person could do to help make our world a better and more peaceful place. Her response to that challenge was to paint skyscapes modeling the diversity and unity of our common sky.

Her first painting was admired by World Friendship Center peace ambassadors on an international exchange from Japan to the West Coast of the United States. The World Friendship Center is a Japanese peace organization that shares stories of survivors of the atomic bomb and promotes a peaceful world without nuclear weapons. JoAnn presented the painting to the peace ambassadors, and when they returned to Hiroshima, they hung her painting at World Friendship Center. JoAnn and her husband then spent 2 years as volunteer directors at the World Friendship Center.

Since returning home to Oregon, JoAnn has continued to add to her series, *Under the Same Sky,* celebrating and promoting peace by painting the diversity, love, and unity of our common sky.

Printed in the United States
by Baker & Taylor Publisher Services